Disney ALICE in WONDERLAND
TAROT DECK
AND GUIDEBOOK

INSIGHT EDITIONS

San Rafael · Los Angeles · London

Contents

Introduction 4

Understanding Your Tarot Deck 6

The Major Arcana 11

0 The Fool 12

I The Magician 14

II The Mystery 16

III The Empress 18

IV The Emperor 20

V The Hierophant 22

VI The Pair 24

VII The Chariot 26

VIII Strength 28

IX The Hermit 30

X The Wheel of Fortune 32

XI Justice 34

XII Suspension 36

XIII Transformation 38

XIV Temperance 40

XV Temptation 42

XVI The Tower 44

XVII The Star 46

XVIII The Moon 48

XIX The Sun 50

XX Judgment 52

XXI The World 54

The Minor Arcana 57

Suit of Flowers 58

Suit of Hedgehogs 72

Suit of Spears 86

Suit of Teacups 100

Tarot Readings 115

**Caring for
Your Deck** 117

**Preparing to
Read Tarot** 118

The Tarot Spreads 120

Introduction

Welcome to The *Alice in Wonderland Tarot Deck and Guidebook*! Now is the perfect time to follow your curiosity down the rabbit hole and begin an exciting new adventure into the world of tarot reading. Created to celebrate the seventieth anniversary of the beloved Disney film, this *Alice in Wonderland Tarot Deck and Guidebook* will take you on a journey through the classic archetypes, trials, and lessons of tarot, experienced through the topsy-turvy lens of Wonderland. You will find creative inspiration from the Mad Hatter, learn how to embrace transformation from the Caterpillar, and learn to appreciate new perspectives as you connect with your intuition through tarot reading.

While many assume that tarot reading is just about predicting the future, its uses go far beyond fortune-telling. Tarot can be a powerful tool for self-exploration and personal growth, and can serve as a valuable guide to help you along life's journeys. It can also offer deep insight into many different situations in your life, from uncovering your true feelings to providing clarity for making decisions to showing you how to get where you want to go. While some do use tarot to reveal a possible future, it's important to remember

nothing is set in stone. Tarot is best at giving situational warnings and advice that can help you make more mindful choices.

The *Alice in Wonderland* tarot deck is full of familiar faces, themes, and iconic moments from the film, thoughtfully chosen to illustrate the archetypal meanings of the original cards. This guidebook explains both the upright and reversed versions of each card. The final chapter includes several spreads for conducting simple readings.

Are you ready to dive in? Don't be late for this very important date—with destiny. Things are about to get *curiouser and curiouser* . . .

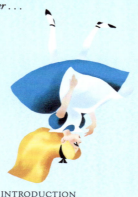

INTRODUCTION

Understanding Your Tarot Deck

Learning to read tarot can seem intimidating, but you'll find it's surprisingly intuitive once you get into it. In this *Alice in Wonderland Tarot Deck and Guidebook*, the classic characters of Wonderland are individually assigned to tarot cards based on how their stories and personalities suit the cards' traditional themes, archetypes, warnings, or lessons. These meanings change depending on whether the card is drawn upright or reversed, so this guidebook offers interpretations for each card in both orientations.

There are 78 tarot cards in a deck, and each one has a different meaning depending on whether it's drawn upright or reversed. The first 22 cards are called the Major Arcana. They represent important themes and major life lessons with lasting impact. Numbered 0 through XXI, they chronologically tell the story of The Fool (the first card in the Major Arcana), a figure who embarks on an exciting and sometimes harrowing journey that ultimately leads to enlightenment and fulfillment.

Beyond the 22 Major Arcana, the rest of the tarot cards in the deck are called Minor Arcana. Representing

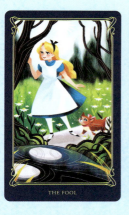
THE FOOL

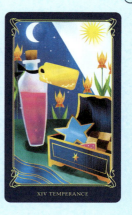
XIV TEMPERANCE

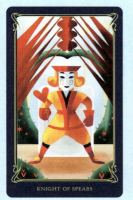
KNIGHT OF SPEARS

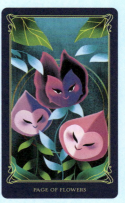
PAGE OF FLOWERS

UNDERSTANDING YOUR TAROT DECK

everyday situations and themes with short-term effects, the 56 Minor Arcana cards are sorted into four suits. In this *Alice in Wonderland*–themed tarot deck and guidebook, the four suits are Flowers, Hedgehogs, Spears, and Teacups, renamed from the classic Wands, Pentacles, Swords, and Cups, respectively.

The suit of Flowers is associated with communication, creativity, travel, and inspiration. It corresponds to the element of fire.

The suit of Hedgehogs represents security, career, duty, and the home. It corresponds to the element of earth.

The suit of Spears represents action, judgment, power, and intellect. It corresponds to the element of air.

UNDERSTANDING YOUR TAROT DECK

The suit of Teacups represents emotions, relationships, and personal connections with family and friends. It corresponds to the element of water.

Each of these suits contains four court cards: the Page, Knight, Queen, and King. They symbolize personality types, behavior patterns, and sometimes, actual people in your life. The remaining cards are numbered I (Ace) to X.

UNDERSTANDING YOUR TAROT DECK

THE MAJOR ARCANA

0 The Fool

Description: The Fool represents someone who, like Alice, is about to follow their curiosity through a life-changing journey. Wide-eyed, yearning for adventure, and a little naive, The Fool eagerly tumbles down the rabbit hole without much worry about where she'll end up or what sort of topsy-turvy scenarios she may encounter along the way.

Upright: You're about to take your first steps on the adventure of a lifetime! Who knows what fantastical characters and confounding situations you may encounter? Maintain optimism throughout this journey. Its challenges will teach you important lessons, and its triumphs will open your eyes to a whole new, wonderful perspective on life.

Reversed: Reversed, The Fool suggests that you may be making yourself late for a very important date. You're on the precipice of an important journey, but you're hesitating. Have you been delaying a potentially life-changing conversation, making excuses to stall a new project, or procrastinating on something you know it's time to begin? Now is the time to bravely step out into the unknown with your head held high, and trust that everything will come together just as it's supposed to.

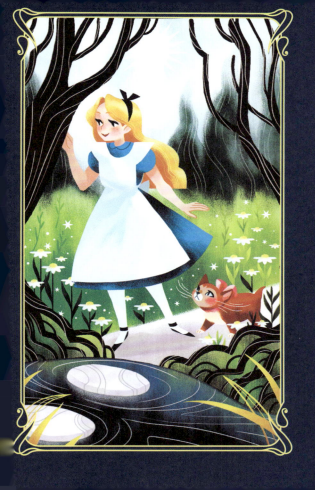

I The Magician

Description: The Magician represents someone who, like the Mad Hatter, is spilling over with enthusiasm and creativity. Just as the Mad Hatter has the ability to pour tea in fantastical ways that defy the laws of physics, The Magician is talented in his own unique way and uses those innate gifts to create the life he wants.

Upright: You're surrounded by inspiration! You see the world through a unique lens; it's time to put your perspectives to good use! Embrace your creativity. There's no telling how far it will take you!

Reversed: Are you feeling a lack of self-confidence? When reversed, The Magician indicates you may be doubting your abilities or lacking the motivation to put your talents to use. You're more than capable of making your own dreams come true. Don't get caught up in convention; stay true to yourself, and you'll make magic.

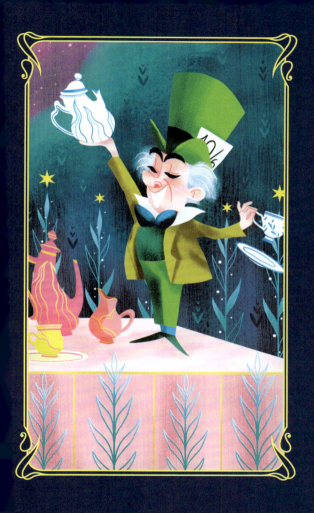

II The Mystery

Description: The Mystery represents wisdom, intuition, and the subconscious. This card, like the Cheshire Cat, carries the message that things aren't always what they seem.

Upright: The Mystery advises you not to take anything at face value. Dig deeper and use your intuition to discover what's really going on under the surface. Take time to consider situations from new perspectives. You may discover that the challenges you're perceiving aren't even truly there at all.

Reversed: The Cheshire Cat often leaves Alice feeling confounded and confused. If you're struggling with a lack of clarity, be still, and listen to your own inner voice. You don't need outside guidance now; following your intuition will get you where you need to go.

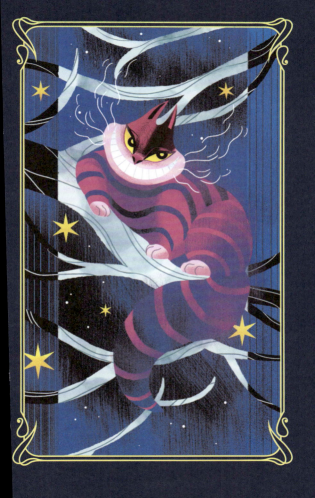

III The Empress

Description: The Queen of Hearts is a revered ruler who loves spending time outdoors playing croquet using flamingos and hedgehogs, and she deeply values her garden of roses. The Empress represents a nurturing woman of power or prominence who, like the Queen of Hearts, loves nature.

Upright: The Empress serves as a reminder to treat others with dignity and compassion—a lesson the Queen of Hearts could stand to take to heart! This tarot card carries a strong theme of appreciating beauty and nature. Make time to cultivate a beautiful environment for yourself, whether by redecorating, spending time outdoors connecting with nature, or planting your very own rose garden.

Reversed: Reversed, The Empress represents an insecure person who goes over the top in her need for adoration. Don't lose your head while looking for validation, and remember that relying on others to feel good about yourself isn't healthy. True confidence and beauty come from within.

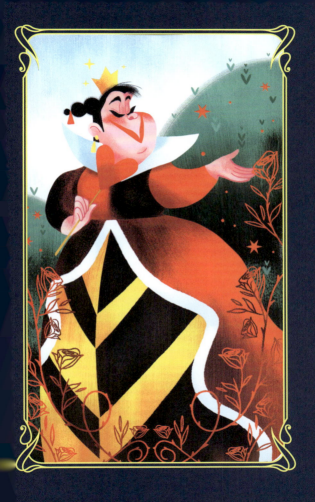

IV The Emperor

Description: The King of Hearts is a gentle leader who often tries to persuade his hot-tempered wife, the Queen of Hearts, to be reasonable and keep her cool. The Emperor represents a patriarch or authority figure who, like the King of Hearts, values good sense and self-discipline.

Upright: Though it may be tempting to lose your temper, The Emperor reminds you of the importance of restraint. Now is the time to resist acting impulsively. Instead, make sure you take time to respond thoughtfully to situations, rather than reacting instinctively in ways you may come to regret in the long run.

Reversed: Reversed, The Emperor suggests you may be struggling with self-discipline or feeling powerless. This tarot card comes as an important reminder: You have more control right now than you think you do. Muster your willpower and determination to set things right.

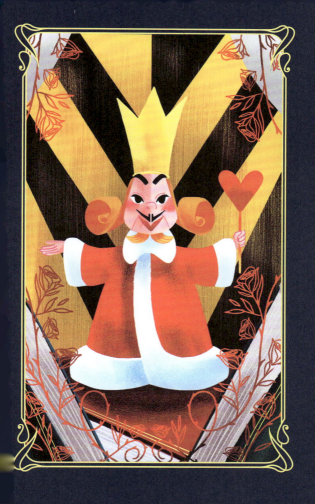

V The Hierophant

Description: Though Alice's attention wanders, her sister tries her best to keep Alice's focus on her history lesson. The Hierophant, like Alice's sister, is a wise teacher who values education, structure, and tradition.

Upright: While there may be a time and place for nonconformity and rebellion, The Hierophant indicates that this is not it. Turn to experienced teachers and authority figures for guidance now. Won't you kindly pay attention? You have lessons to learn.

Reversed: Are you clashing with an authority figure in your life? If you're feeling pressure to conform to traditions or ways of thinking that just don't suit you, perhaps it's time to follow your own heart—or the White Rabbit—down a different path entirely. Who knows what wondrous adventures may await you?

THE MAJOR ARCANA

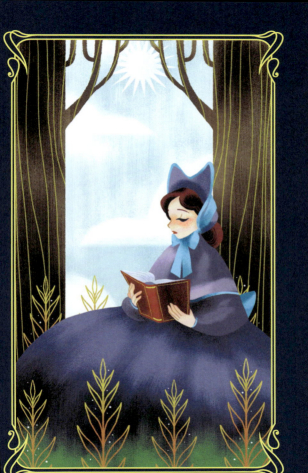

VI The Pair

Description: Tweedle Dee and Tweedle Dum are harmonious and completely in sync with each other. The Pair represents a partnership, friendship, or collaboration that is as effortless, united, and congruous as the bond between Tweedle Dee and Tweedle Dum.

Upright: While The Pair represents a harmonious union, this tarot card also carries an element of choice. Even the best friendships and partnerships take work to maintain. Will you choose to nurture the connections you value the most? Are any adjustments needed in those relationships? Check in with yourself, and communicate what's on your mind openly.

Reversed: When reversed, The Pair indicates that a connection you once valued has gone topsy-turvy. You now have a decision to make: Will you try to repair this bond, or is it time to walk away? Even Tweedle Dee and Tweedle Dum get into little battles sometimes, but if a connection is no longer serving you, it may very well be time to cut ties and move on.

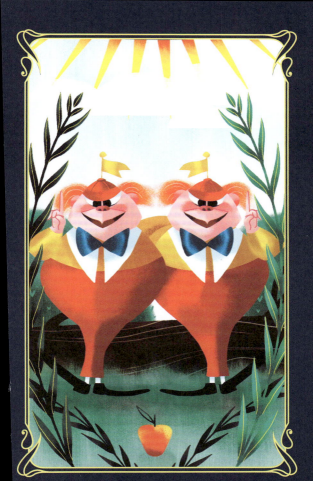

VII The Chariot

Description: The Chariot represents action, triumph, movement, and momentum. Reversed, this tarot card represents the kind of helplessness and insignificance that Alice feels as she's swept away by the force of her sea of tears.

Upright: The message of The Chariot is clear: Stay the course! You're the master of your own destiny now. You will overcome any obstacle in your way, so long as you focus, stay confident, and keep pushing forward toward your goal.

Reversed: Are you feeling as though you're being swept along by forces you're powerless to influence? You may be feeling listless, letting the currents take you where they will. Don't allow yourself to be swept down paths that aren't right for you. Remember, you do have the power to steer your own course and choose your own direction.

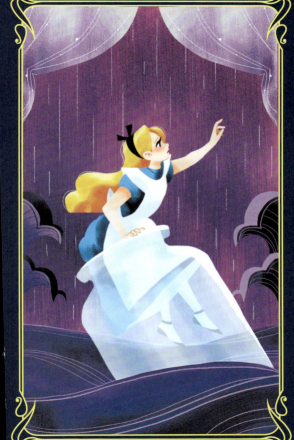

VIII Strength

Description: Traditionally depicting an image of a mighty lion that's been tamed using a soft, compassionate touch rather than brute force, Strength represents gentle persuasion and leading with kindness.

Upright: When you're faced with challenges that seem frightening and insurmountable, Strength reminds you to stay calm. Acting out of frustration won't help the situation now. Face any obstacles that you encounter with a brave, levelheaded collectedness. If you do, you may just discover that the frightening beast you thought you were up against is no more ferocious than a dandelion.

Reversed: Reversed, Strength indicates self-deprecation or a loss of confidence. You may be feeling uncomfortably vulnerable, but remember that there's strength in vulnerability too. Sometimes, we need to let our guard down to really connect with others—and ourselves. Strength doesn't always come from being boastful, loud, and ostentatious; there's strength in being tender and soft too.

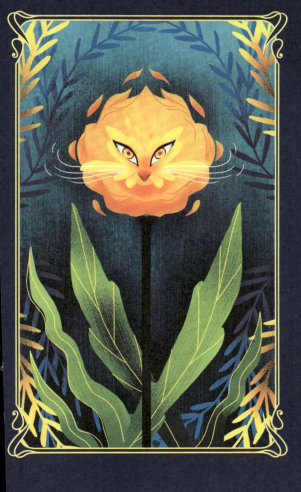

IX The Hermit

Description: Hidden in his teapot, the Dormouse enjoys time spent alone pondering ambiguous rhymes ("Twinkle, twinkle, little bat, how I wonder what you're at...."). The Hermit is a figure who also values privacy, seclusion, and deep thinking.

Upright: The Hermit is a clear sign that it's time to take a step back. It can be difficult to evaluate situations and relationships with a healthy perspective when you're caught up in the middle of them. Making room for a bit of alone time and introspection will do you a world of good.

Reversed: Spending time by yourself can be recharging and healthy, but when reversed, The Hermit suggests that introversion has turned to isolation and loneliness. You may be overthinking things and creating a lot of needless worry for yourself. Remember to pop out of your hideaway and join your friends at the tea party every now and then!

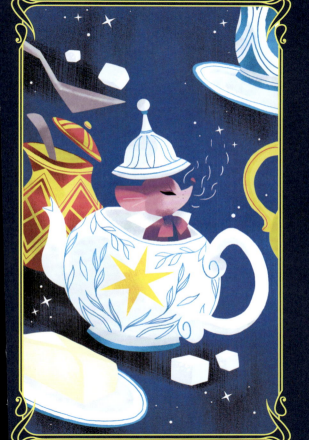

X The Wheel of Fortune

Description: The Dodo stands atop a rock as his sea creature friends run around him in a circle to dry off. Waves keep coming one after another to drench the sea creatures, but still, they carry on happily as each wave recedes, and the sun shines on them again. The Wheel of Fortune is a reminder that life is always changing; good times don't last forever, and neither do the bad ones.

Upright: The Wheel of Fortune is a celebration of change. Life isn't meant to be static; it's constantly moving and evolving. Sometimes, this tarot card represents a pivotal moment or an unexpected event that changes the course of your life. Embrace change with positive optimism, and trust that everything will work out just as it should.

Reversed: Do you feel as though you've been running in circles and not making any real progress? Reversed, The Wheel of Fortune suggests you're feeling stagnant and stuck. It's time to step out of your routine. Shake things up and change directions to turn your luck around and open yourself up to amazing, new opportunities.

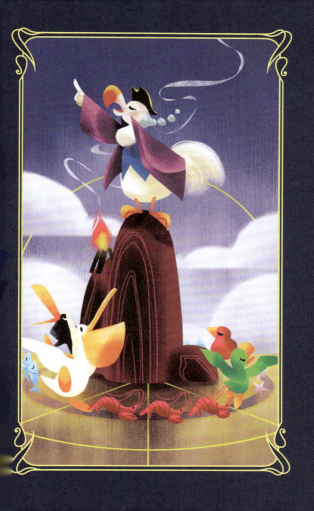

XI Justice

Description: The King of Hearts persuades his queen to control her temper and presides over a courtroom trial for Alice. The tarot card Justice represents fairness, morality, ethics, and consequences.

Upright: Being objective can be difficult when it comes to matters you're passionate about or personally invested in, but Justice encourages you to be fair and rational. Make sure you really understand the big picture and are seeing things from a healthy, balanced perspective before making decisions.

Reversed: Reversed, Justice indicates imbalance and inequality. Step back and evaluate the exchanges of power in your life. Are you being treated fairly at work? Are your needs being met in your friendships and relationships? Are you, in turn, treating others equitably and putting a healthy amount of energy into the connections that mean the most to you? Something in your life is out of balance. It's time to uncover the problem and work to create more balance and harmony.

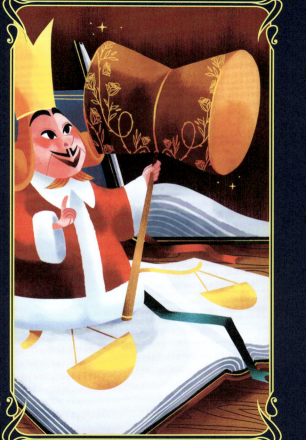

XII Suspension

Description: Alice's imagination and curiosity send her tumbling down the rabbit hole into an exciting, topsy-turvy world of adventure. Suspension represents the importance of taking breaks to explore, dream, and see the world from new perspectives.

Upright: Suspension encourages you to step outside of your usual routines and familiar perspectives. Explore new points of view! Even if you don't adopt them as your own, understanding the world from new angles will make you a well-rounded person. Like Alice, stay *curiouser and curiouser* . . .

Reversed: Are you feeling overwhelmed and unsure of which path to take? Reversed, Suspension suggests indecision and delays. Don't overthink things now, because there are forces influencing this situation that are out of your hands. Sometimes, you just have to surrender control, take a leap of faith, and let the cards fall where they will.

THE MAJOR ARCANA

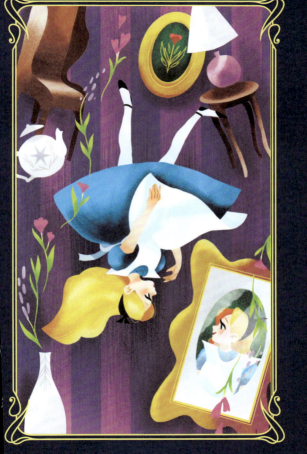

XIII Transformation

Description: Just as the Caterpillar transforms into a beautiful butterfly, Transformation symbolizes transitions, metamorphosis, and the shift between beginnings and endings.

Upright: You're going through a defining period of transformation. Look to the example of the wise Caterpillar, and welcome whatever life brings you with grace. Whether you're starting a new career, relocating to a new home, or going through a personal, inner change, trust that this process will bring you wisdom and happiness.

Reversed: Sometimes, it can be difficult to accept change. Moving on from what's familiar can feel daunting. When reversed, Transformation reminds you that stalling the inevitable will only drag out the process longer. Remember, beginnings and endings are natural parts of life. The transition you're delaying is a necessary one, so it's time to take the next brave step forward.

THE MAJOR ARCANA

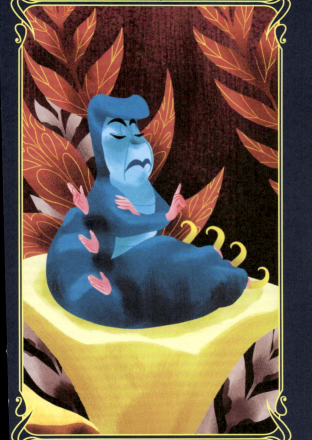

XIV Temperance

Description: In Wonderland, Alice sometimes finds it difficult to reach the perfect balance between growing bigger and smaller as she partakes in the transformational, labeled bottle and cookies. The tarot card Temperance represents balance, give and take, and blending different elements together harmoniously.

Upright: Temperance suggests that you're well on your way to creating the life you want. Now is no time for nonsense! Take care to stay sensible as you manage all the tasks and projects you've been working on that will eventually come together and create success. It's important now to practice moderation and make sure you're considering all decisions carefully.

Reversed: When reversed, Temperance indicates excess and a lack of forethought. If you've been pursuing instant gratification, it's time to reconsider your actions. Make sure you're behaving in ways that will benefit you in the future and set you up for long-term success. Take care not to indulge in temptation, but rather, practice moderation. Like Alice, you're excellent at giving yourself good advice. It's time to follow it!

THE MAJOR ARCANA

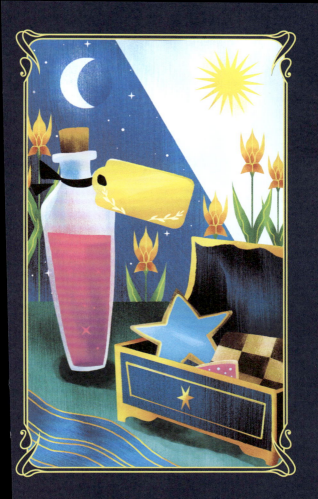

XV Temptation

Description: The Walrus lures the Curious Oysters from their safe seabed with delightful promises—but allowing themselves to be coaxed ashore, against the good advice of Mother Oyster, is ultimately the oysters' undoing. This tarot card warns against giving into temptation.

Upright: *Oh, dear!* The tarot card Temptation is seen as a wake-up call. You may be feeling tempted to indulge in something that will be instantly gratifying but will lead to negative outcomes in the long run. This tarot card also indicates that you may be feeling powerless to stop a behavior or situation, but it also carries the assurance that you do, in fact, have far more control than you think you do.

Reversed: Reversed, Temptation suggests that you've turned a bad habit or negative situation around and are now on the right track. Before you sit down to a celebratory tea party, know that Temptation reversed also carries a word of caution: Even though you're headed in the right direction now, temptation is still there, and things could very well go back to the way they were if you're not vigilant. So, stay focused, alert, and move bravely forward in this new, healthier direction.

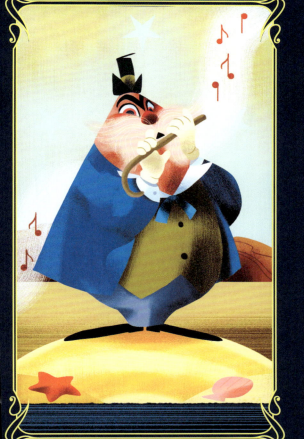

XVI The Tower

Description: Disaster strikes at the White Rabbit's house when Alice indulges in a cookie that unexpectedly makes her grow to a gigantic size. The Tower represents an abrupt, sudden catastrophe or collapse.

Upright: While The Tower symbolizes calamity and destruction, it's important to recognize that its message isn't always as doom and gloom as it sounds. Sometimes, things need to end to make room for new beginnings. The Tower represents an unexpected revelation or event that shakes something important in your life—whether a relationship, job, personal truth, belief, etc.—down to its very foundations. But from those bare foundations, you have an opportunity to build something stronger and more solid.

Reversed: When reversed, The Tower indicates that the cataclysmic revelation or event symbolized by its upright orientation is being stalled. Are you putting off an important and potentially life-changing conversation? Perhaps you're hesitant to bring something to an end, even though you know it's necessary? Sometimes, there's an element of denial to The Tower reversed. Be honest with yourself. Delaying the inevitable is only delaying the opportunity and freedom that will come after the dust settles.

THE MAJOR ARCANA

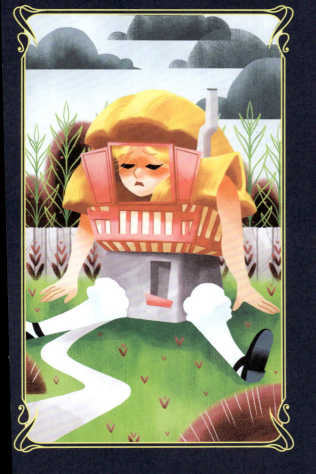

XVII The Star

Description: Like the beautiful White Rose soloist Alice meets in the garden, The Star represents serenity, composure, and hope.

Upright: The Star glows like a glorious beacon of hope, encouraging you to hold on to your dreams, no matter how lofty and out of reach they may seem. This tarot card reminds you that positivity and hope will help you manifest your most cherished desires, wishes, and aspirations. Know that you're supported, even when that support isn't always obvious to you.

Reversed: Reversed, The Star suggests you're feeling vulnerable and defensive, to the point of withdrawal. You may have lost hope that a dream will come true and are retreating from its pursuit entirely to avoid being hurt by disappointment. Even when reversed, the hopeful message of The Star still remains. Remember that vulnerability isn't always a bad thing. Sometimes, the deepest connections and best outcomes form from it.

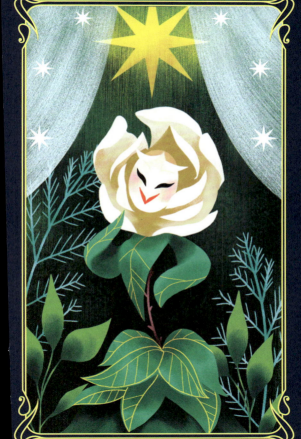

XVIII The Moon

Description: Just as Alice has lost hope (and her way) in the Tulgey Wood, a crescent moon appears above her that slowly reveals itself to be no moon at all, but rather the grin of the Cheshire Cat. The Moon tarot card represents illusion, confusion, and deception.

Upright: Like the confounding, disappearing Cheshire Cat, things aren't always what they appear to be. The Moon warns you not to take anything at face value now. Take care to listen to your instincts when evaluating situations or people, because those messages will tell you what you need to know.

Reversed: Just as Alice feels hopeless as she cries in Tulgey Wood, when The Moon is reversed, it indicates fear, confusion, and worry. You may have been deceived by illusions and trickery and now don't know who to trust or which way to go. Don't give into despair, for you will come out of this conundrum. The guidance you seek is nearby; be brave enough to reach out and ask for help when you need it.

THE MAJOR ARCANA

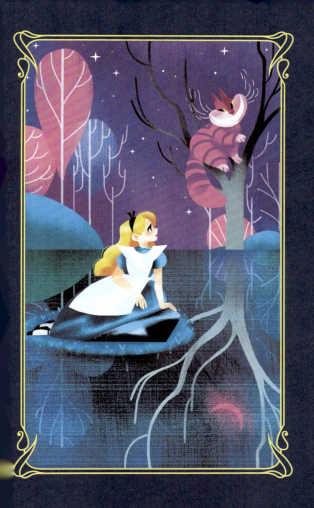

XIX The Sun

Description: The Sun is a celebratory tarot card that represents a very merry time indeed! Whether you gather with charismatic friends for an unbirthday party or share happiness in a slightly more sensible way, The Sun symbolizes joy, warmth, and success.

Upright: Like the cheery glow of The Sun, you're beaming with a sunny, happy glow. Be present, and bask in the warmth of this joyful time. During tarot readings that search for answers about potential outcomes, drawing The Sun is a very strong sign of a successful, positive result. Gather friends, put on a pot of tea, and spread this cheer!

Reversed: Reversed, The Sun represents sadness, poor outcomes, and disappointment. Things haven't turned out the way you'd hoped they would, and now you're feeling discouraged. Remember, cloudy days don't last forever. The sun will soon return to cheer you up and shine light on new opportunities for happiness.

THE MAJOR ARCANA

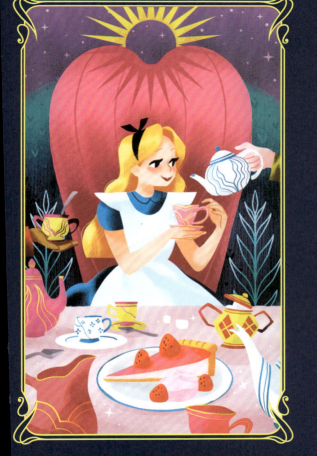

XX Judgment

Description: While the White Rabbit blows his trumpet to announce the arrival of the Queen of Hearts, the tarot card Judgment announces the arrival of an important realization. Judgment marks the time to make amends for past blunders or wrongdoings and forgive yourself.

Upright: Everyone makes mistakes; that's the simple nature of it. Whether you've hurt someone's feelings, made a poor judgment call, or found yourself late for a very important date, Judgment encourages you to make amends and forgive yourself. You've come so far along your journey and grown so much along the way. It's time to leave regrets and guilt in the past and move forward.

Reversed: Like a blaring trumpet, you're being called to embrace something new but are ignoring it. Sometimes, Judgment reversed represents that you're being too hard on yourself, and that it's time to silence your inner critic and embrace yourself for who you are. Other times, Judgment reversed can mean that you're refusing to embrace a personal realization that's right in front of you, trying to get your attention as boisterously as a trumpet. Let go of limiting beliefs, ideas, and behaviors that you've outgrown, and allow yourself to bloom.

THE MAJOR ARCANA

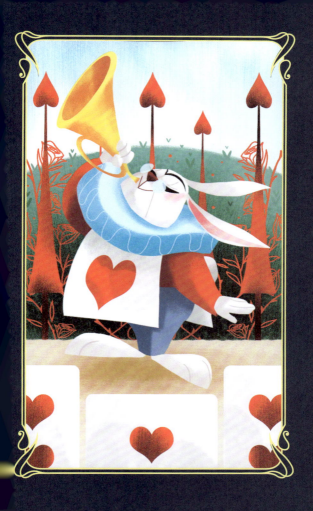

XXI The World

Description: Alice's adventures in Wonderland begin and end near a rabbit hole at the base of a tree on a beautiful day. The World represents the satisfying completion of a long journey.

Upright: You've come to the end of an important, life-changing expedition. Whether this refers to actual travel or a more personal, internal journey, you've been met with confounding challenges and joyous breakthroughs and have learned many lessons along the way. You've reached your destination as a wiser, more accomplished person. Enjoy your success.

Reversed: When reversed, the ending symbolized by The World in its upright orientation is being stalled. There may be unfinished business or loose ends that need to be tied up before you can truly consider this journey completed, or you may be intentionally delaying closing a chapter of your life. Remember, the chapter must conclude eventually. You never know what excitement and opportunity await you on the following page. It's time to let go of the past and let your curiosity lead you on a brand new, wonderful adventure.

THE MAJOR ARCANA

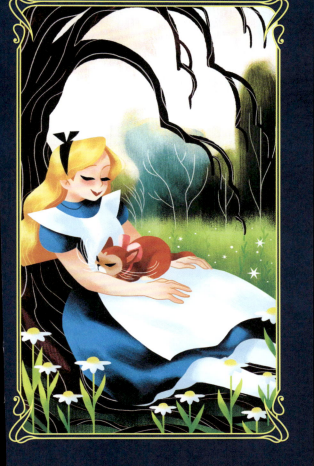

Suit of Flowers

King of Flowers

Upright: An ostentatious leader, the King of Flowers is known for his loud personality and visionary nature. He doesn't just sound off orders though; the King of Flowers knows that he doesn't have all the answers himself and willingly seeks input from others before making up his mind. Creativity and collaboration will help you manifest your goals and dreams.

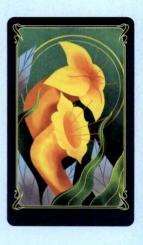

Reversed: When reversed, the King of Flowers becomes haughty and demanding. His downfall is that he closes himself off to the valuable input and opinions of others and leads with an arrogance that creates resentment. Remember, considering others' perspectives and ideas isn't a weakness; it's a strength.

THE MINOR ARCANA

Queen of Flowers

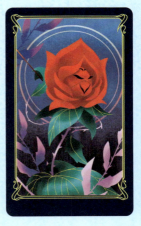

Upright: The Queen of Flowers is a social person who takes pride in her appearance and speaks her mind with elegance and authority. Admired by others, she commands attention wherever she goes. It's time to hold your head up high, put your enviable talents and skills on display, and embrace the unique traits that make you who you are.

Reversed: Reversed, the once-confident Queen of Flowers wilts from the spotlight and becomes a shy wallflower. You may be feeling like a common weed amongst a garden of beautiful flowers. The key to finding confidence again lies in reconnecting with the things you're most passionate about. Rediscovering and pursuing your favorite interests will energize you. You'll be in bloom again in no time!

Knight of Flowers

Upright: The Knight of Flowers represents a fiery, passionate, temperamental person. One moment, he's sociable and enjoyable; the next moment, he may be dumping rainwater on your head and chasing you out of his garden. Take inspiration from his action-oriented nature. The Knight of Flowers is a sign to actively pursue your interests and put meaningful momentum behind your goals.

Reversed: Reversed, the Knight of Flowers expends a lot of energy and time trying to reach a goal but becomes frustrated by a lack of progress. It may be time to pause and regroup. If your attention is split between too many tasks, it's time to prioritize them so you can refocus your energy and start making meaningful progress toward your aspirations.

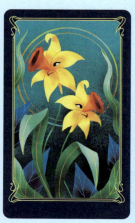

THE MINOR ARCANA

Page of Flowers

Upright: The Page of Flowers represents a sweet, social person. Optimistic and eager to learn about and explore new things, the Page of Flowers is a well-liked person who makes friends easily. Dreaming, brainstorming, and freely embracing your imagination will benefit you now. Write down all your ideas and dreams. Eventually, you'll refine them, and they'll become the foundation of your goals and future.

Reversed: Reversed, the Page of Flowers suggests that you're allowing pessimism to prevent you from exploring your potential. If you're lacking confidence, remember that even the most beautiful flowers in the garden started out as humble seeds. Embrace the sunlight, pursue whatever makes you feel most radiant, and you'll bloom before you know it.

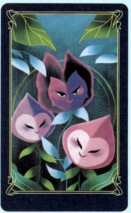

Ace of Flowers

Upright: The Ace of Flowers represents new inspiration and ideas. You're feeling an exciting surge in your creativity. Embrace your visionary ideas, and use them to motivate your next steps. There's no telling how far your innovation will take you.

Reversed: Are you feeling uninspired or experiencing a creative block? Step out of your current routine to get out of this slump. Experiencing new things will help reinvigorate you and stimulate your creativity again.

II of Flowers

Upright: II of Flowers suggests that you're in the beginning stages of manifesting a goal that you're very excited about. While you may still be ironing out the details and figuring out how to make your dreams a reality, this card is a sign that things are on the right track.

Reversed: Reversed, II of Flowers indicates that you may not be acknowledging the full reality of a situation. You may be refusing to see things as they are, preferring to allow your optimism and idealism to outshine any red flags or warning signs. Stay optimistic but also realistic.

THE MINOR ARCANA

III of Flowers

Upright: III of Flowers reminds you of the importance of teamwork, cooperation, and good communication. You can't accomplish everything all by yourself. Ask for support to bring your creative vision to life and help your plans reach their full potential.

Reversed: Reversed, III of Flowers indicates that there's a lot of miscommunication or a lack of understanding within a collaborative group in your life. Better communication will be the key to getting things back on track. Make sure that everyone knows what's expected of them and understands the goal to start regaining momentum.

THE MINOR ARCANA

IV of Flowers

Upright: IV of Flowers is an exciting, celebratory card suggesting that you'll have cause to throw a fun tea party of your own very soon. This could be a family reunion, housewarming party, birthday, or a celebration for another milestone in your life. Enjoy this exciting time with friends and loved ones.

Reversed: Reversed, the celebratory nature of the IV of Flowers is turned inward. You're experiencing a more personal accomplishment, such as a positive behavior change or successfully setting personal boundaries. Whatever the journey, you're much happier now. This card is reminding you to be proud of yourself and celebrate this achievement.

THE MINOR ARCANA

V of Flowers

Upright: V of Flowers represents conflicts and competition. You may feel as though others aren't appreciating your contributions or ideas, and this is causing resentment. Openly communicate your perspective and feelings to clear the air and restore balance to this situation.

Reversed: Are you avoiding a necessary confrontation? Reversed, V of Flowers suggests that it's time to stand up for yourself. Like Alice as she chastises the Red Queen during her trial, everyone has their breaking point. Avoiding conflict will only make things more explosive when you do finally say what's on your mind, so it's best to get it out in the open sooner rather than later.

THE MINOR ARCANA

VI of Flowers

Upright: VI of Flowers is a victorious card. This is your time to shine! Others have noticed your success, and you're finally getting the recognition you deserve. Soak up the praise, and be proud of what you've achieved.

Reversed: Reversed, VI of Flowers represents an unhealthy self-image. Either you're lacking confidence and being self-deprecating, or your ego is getting the better of you. Examine your feelings and behaviors to restore a better balance.

VII of Flowers

Upright: VII of Flowers advises you to be defensive. You're facing challenges and rivalry. Now isn't the time for politesse and backing down. Keep your shoulders squared, hold your ground, and remember that you've earned your place in this garden.

Reversed: Reversed, VII of Flowers suggests that you're feeling as though you're fighting a losing battle and ready to give up. This card reminds you that help can come from surprising places just when we least expect it. Keep your eyes open for an unexpected new ally.

THE MINOR ARCANA

VIII of Flowers

Upright: VIII of Flowers represents fast-paced change and a flurry of activity. Things are happening quickly now, and this new change of pace can feel dizzying. Try to go with this new flow, and embrace the momentum.

Reversed: Reversed, VIII of Flowers represents delay. Things aren't moving along as quickly as you'd expected them to, and you're frustrated by this lack of progress. Remember that some things are just out of your control. Stay adaptable to overcome this setback.

THE MINOR ARCANA

IX of Flowers

Upright: IX of Flowers advises you to have courage while defending your ideas. You may be feeling like you're alone in their defense, but that doesn't mean that you should back down. Rely on your vision and passion to overcome current challenges.

Reversed: You may be feeling as though you're facing a barrage of obstacles, and this opposition is finally starting to slow you down. Your me-against-the-world attitude might be hindering you rather than helping you now. Listen to others' advice, and accept help when you need it.

THE MINOR ARCANA

X of Flowers

Upright: X of Flowers represents burdens and overwhelming responsibilities. You're feeling stressed and exhausted by the amount and magnitude of your duties and have lost your joie de vivre. Reexamine your commitments to make sure they're really worth it for you.

Reversed: Reversed, X of Flowers suggests that you've lost sight of your original motivation and are swept up in tasks that you don't really care about. It's time to rediscover your passion, even if that means making a major change in your life. Life is too short to go through it feeling listless and complacent. What are your dreams? Reconnect with them, and use them as motivation to reignite your spark.

Suit of Hedgehogs

King of Hedgehogs

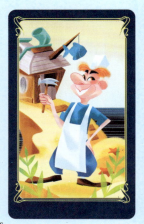

Upright: The King of Hedgehogs is a masterful person who built his success through hard work and persistence. Take inspiration from the Carpenter, who uses his skills to build a restaurant where he can make his dinner dreams come true. Set yourself up through discipline and dedication.

Reversed: Reversed, the King of Hedgehogs symbolizes a negative relationship with work or wealth. Are you spending money impulsively rather than in ways that set you up for long-term success? Perhaps you've gone the other way and are being miserly, self-interested, and consumed with acquiring wealth. Examine your relationship with money and your career to find the imbalance and correct it.

Queen of Hedgehogs

Upright: The Queen of Hedgehogs is a nurturing, practical figure who lives a fulfilling life of abundance. Like the Mother Bird, she's a maternal, protective person, and she takes pride in maintaining a comfortable home. The Queen of Hedgehogs advises you to stay resourceful, nurturing, and kind.

Reversed: Reversed, the Queen of Hedgehogs has difficulty finding the perfect balance between her work and home life. It's time to step back and make sure the things and people you care most about are getting the attention and support they need.

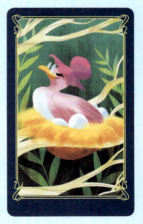

THE MINOR ARCANA

Knight of Hedgehogs

Upright: The Knight of Hedgehogs is as industrious and diligent as Bill the Lizard, who risks it all trying to dutifully save the White Rabbit's house after Alice grows to gigantic proportions. The Knight of Hedgehogs reminds you to stick to your routine, work hard, and focus on the details.

Reversed: Reversed, the Knight of Hedgehogs is listless and lacking motivation. It's time to shake yourself out of this bout of laziness and get back to work. Reconnect with the things you're most passionate about to re-ignite your momentum. Creating new, exciting goals for yourself based on those inspiring interests will spur you back into action.

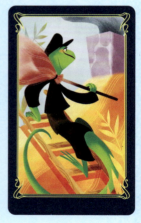

Page of Hedgehogs

Upright: The Page of Hedgehogs is eager to be helpful and learn new skills but is a bit ineffective at present. Opportunity is all around you now, and so is the potential for working toward meaningful success and material stability. Explore new opportunities with common sense and your long-term goals in mind.

Reversed: Reversed, the Page of Hedgehogs becomes disappointed and discouraged. An opportunity for quick material success hasn't gone according to plan. Remember, if things seem too good to be true, they probably are. There aren't any shortcuts to your dreams; you'll have to put hard work into making them come true. Trust that it will be worth it.

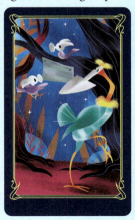

THE MINOR ARCANA

Ace of Hedgehogs

Upright: Exciting opportunities are heading your way that carry the potential to be very beneficial to you. This could refer to a lucrative new job, a fresh start in a new home, or the pursuit of a new goal that could be very profitable.

Reversed: Reversed, the Ace of Hedgehogs represents a lack of profitable potential. If you're being presented with an opportunity that seems too good to be true, make sure to investigate it further to avoid disappointment. Due diligence is called for now.

THE MINOR ARCANA

II of Hedgehogs

Upright: You may be struggling to balance your attention between work and home. Reexamine your responsibilities and priorities to make sure the things and people who are most important to you are getting the attention they deserve.

Reversed: Reversed, II of Hedgehogs represents scattered, unfocused effort. You may be struggling with more tasks and responsibilities than you can comfortably handle. Take a look at how you're spending your time and energy, and try to find tasks that you can either delegate to someone else or put on the back burner.

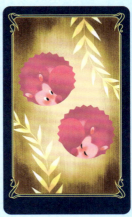

THE MINOR ARCANA

III of Hedgehogs

Upright: III of Hedgehogs is a clear indication your key to success lies in collaboration and cooperation. Some goals are too great to be reached alone. Seek advice, guidance, and support from others to help you manifest your vision.

Reversed: Reversed, III of Hedgehogs suggests that a collaboration that once had great potential is falling apart. Whether there's a lack of communication, an unfair power dynamic, or the goal has become unclear, it's apparent that things aren't coming together as planned.

THE MINOR ARCANA

IV of Hedgehogs

Upright: IV of Hedgehogs represents material stability and harmony at home. You're managing your resources carefully and are being rewarded with comfort and security. Continue to practice moderation and plan carefully for your future.

Reversed: Reversed, IV of Hedgehogs suggests that there's an imbalance in the way you're managing your resources. You may be spending money carelessly, or accumulating wealth may have become an overwhelming focus in your life that's clouding your judgment.

V of Hedgehogs

Upright: V of Hedgehogs represents instability involving resources or life at home. This could refer to conflict within your family or a precarious situation involving finances or a career. Make decisions carefully, and conserve resources to see you through this challenging time.

Reversed: While the upright V of Hedgehogs represents conflict and instability, its reversed orientation suggests that things are finally looking up and this challenging period is ending. Sometimes, this tarot card indicates that you'll be getting much-needed help from an outside source.

THE MINOR ARCANA

VI of Hedgehogs

Upright: VI of Hedgehogs indicates that you're in a place of abundance now and that it's time to share that wealth with those less fortunate. Remember the people who helped you along your way to success, and share its rewards with them.

Reversed: Reversed, VI of Hedgehogs represents a debt or unfair exchange. Carefully examine contracts before agreeing to them to avoid being swindled. If you have any outstanding debts, this tarot card is a sign to prioritize making good on them.

THE MINOR ARCANA

VII of Hedgehogs

Upright: VII of Hedgehogs shows that you're working hard and planning carefully to set yourself up for the future. Making decisions with a long-term focus should be your goal now. Instant gratification is fleeting; focus on creating solid foundations for future success.

Reversed: Reversed, the VII of Hedgehogs suggests that you may be losing motivation because you're not seeing immediate rewards for your hard work. Remember, the greatest rewards often take time and careful planning to manifest.

VIII of Hedgehogs

Upright: VIII of Hedgehogs encourages you to keep working hard to learn new skills. Repetition and dedication aren't always exciting, but they'll build skills that will benefit you greatly in the future. Take pride in your work. You're doing great.

Reversed: Reversed, VIII of Hedgehogs indicates that you're not spending your energy wisely. Either you're feeling bored with the monotony of mundane tasks, or you're focusing too much on the details, at the expense of the bigger picture. A solution will show itself when you take a break from this situation to examine it with more clarity.

THE MINOR ARCANA

IX of Hedgehogs

Upright: Like the regal Queen of Hearts, you're enjoying luxury and abundance. You have all the material resources you need to feel comfortable and secure. Relax, pamper yourself, and gather friends for a game of croquet. It's time to enjoy yourself.

Reversed: Reversed, IX of Hedgehogs suggests that you're being too hard on yourself. You may be feeling frustrated by setbacks that have stalled your success, but know that these delays are temporary. Try to relax and let the cards fall where they may.

THE MINOR ARCANA

X of Hedgehogs

Upright: X of Hedgehogs represents accumulated wealth, satisfaction, and sustained success. You've worked hard and are now enjoying the resulting comfort and stability. This tarot card can also symbolize a happy, stable home and supportive family.

Reversed: Reversed, the X of Hedgehogs invites you to examine your feelings about wealth and status. You may have everything you need, but are you truly happy with your life? Don't be afraid to make changes in your life in the pursuit of happiness, even if they don't make sense to other people. You have to build the life that's right for *you*, regardless of expectations and the status quo.

THE MINOR ARCANA

Suit of Spears

King of Spears

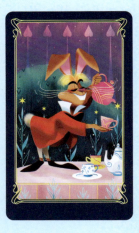

Upright: The King of Spears represents a shrewd, calculating person who commands respect. Like the March Hare, he has a very assertive way of communicating and is not easily moved by the emotions of others. This tarot card advises you to be clear, focused, and confident in your interactions with other people.

Reversed: When reversed, the King of Spears' confidence goes to his head and leads to a cold and detached attitude. Remember, just because something may not personally affect you doesn't mean that it doesn't matter. If someone shows up at your tea party asking for help, show them compassion.

Queen of Spears

Upright: The Queen of Spears has a strong sense of fairness and is willing to fight for what she feels is right. Like Alice at her trial, the Queen of Spears is direct and levelheaded; she doesn't tolerate nonsense. This tarot card comes as a reminder to stay confident even in the face of adversity and to stand up for yourself when necessary.

Reversed: Reversed, the Queen of Spears represents someone who's become aggressive and demanding. Her emotions are out of balance; either she's shut them off entirely and has become cold and distant, or she's lost a sensible perspective and is being led by her emotions. It's time to find better equilibrium between the head and heart.

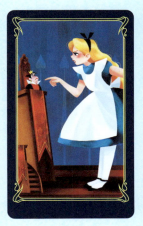

THE MINOR ARCANA

Knight of Spears

Upright: Like the Queen of Hearts' dutiful Card Soldiers, the Knight of Spears is always ready for action. He bravely charges forward to meet challenges head-on. If you've been procrastinating or wondering when the time will be right to make your move, this is your sign to square your shoulders, hold your head high, and act now.

Reversed: Reversed, the Knight of Spears becomes unfocused, irritable, and as scattered as a fallen pack of cards. He's not using his energy wisely, so he's not seeing the desired outcome. It's time to regroup, refocus, and get your thoughts in order before carrying on.

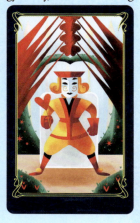

THE MINOR ARCANA

Page of Spears

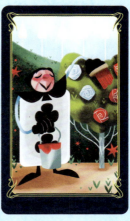

Upright: The Page of Spears represents someone who's eager to do their best, though their lack of attention to detail often creates mistakes—like planting white royal roses instead of red ones! Though blundering, the Page of Spears tries his best and will always try to right his wrongs. Be patient with yourself, and use mistakes as learning opportunities.

Reversed: When reversed, the Page of Spears represents a know-it-all who most certainly does not, in fact, know it all. Their overconfidence may come across as snobbish and pompous. Remember, everyone starts somewhere. It's okay to admit that you don't yet have all your cards in order and are still learning.

THE MINOR ARCANA

Ace of Spears

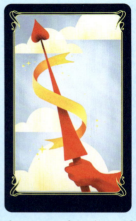

Upright: The Ace of Spears represents new ideas and clarity. You've had a breakthrough and are feeling inspired to brainstorm plans for your next great adventure. This is a great time for strategizing.

Reversed: Have you been feeling as lost and confused as poor Alice when she's lost in Tulgey Wood? Are you unsure of where to go from here? If you're feeling foggy or listless, take time to think about what you really want. Giving yourself an exciting goal will help you regain motivation and clarity.

THE MINOR ARCANA

II of Spears

Upright: II of Spears indicates that you're caught in a confusing situation and are feeling conflicted. A decision looms in front of you, but you're having trouble making up your mind. Take your time in making your decision. Don't come to any conclusions until you're sure you have all the information you need.

Reversed: When reversed, II of Spears suggests that you're in an exhausting conflict that should have been resolved by now. You're not on the same page with someone in your life, and it's clear now that this disagreement isn't going to be productive. If you aren't being understood or heard, it may be time to follow Alice's lead by leaving the tea party and going your own way.

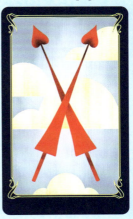

THE MINOR ARCANA

III of Spears

Upright: III of Spears symbolizes heartache and hurt feelings. You're feeling disappointed and let down, but remember that these feelings are temporary. Your heart will heal, and you'll find happiness again soon.

Reversed: When reversed, III of Spears represents emotional healing. You're coming to terms with past disappointments or painful losses. This process may take time, so be patient with yourself, and know that you're on the right track.

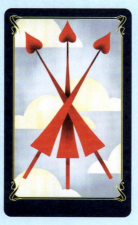

IV of Spears

Upright: IV of Spears is a clear sign that you need to rest to ensure that you're in tip-top shape for what lies ahead. Make time for self-care and relaxation, and prepare for whatever challenges and excitement you may soon be met with. You'll come out of this restful period ready for your next great adventure.

Reversed: When reversed, the restful energy of the IV of Spears tarot card turns to listlessness. You're feeling as though you're suspended in limbo. New opportunities to move forward will reveal themselves when you break from routine and try to see things from new perspectives.

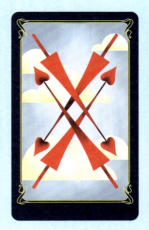

THE MINOR ARCANA

V of Spears

Upright: Whether you're locked in conflict with the tempestuous Queen of Hearts or frustrated by misunderstandings and poor communication with the Mad Hatter, the V of Spears is known as the ultimate conflict card. Whatever battle you've found yourself in, know that now isn't the time to back down. You'll have to be creative and determined to gain the advantage.

Reversed: Reversed, the V of Spears suggests that it's time for a truce. Conflicts can't last forever. Sometimes, the only sensible thing to do is shake hands with your opponent, agree to let bygones be bygones, and move on.

VI of Spears

Upright: You've recently been through a difficult, challenging time, and now you need to care for yourself, rest, and process all that's happened. VI of Spears symbolizes the peaceful period after a conflict when moving on is necessary.

Reversed: Reversed, VI of Spears suggests that you've recently come through a challenging period and are now having difficulty coming to terms with an outcome that you didn't want. Take care not to allow yourself to become gloomy; there are better opportunities ahead.

THE MINOR ARCANA

VII of Spears

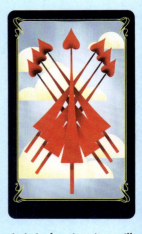

Upright: VII of Spears represents deception and trickery. Someone may be trying to confuse or hoodwink you. Pay close attention to your intuition now, and trust your gut feelings. If a situation feels *off* to you now, it probably is.

Reversed: Reversed, VII of Spears declares that it's time to face the truth. It's natural to want to believe the best of people and stay optimistic that situations will turn out for the best, but make sure you're not being naive. Acknowledging the truth about personal connections and situations can be difficult, but it's time to be honest with yourself about this predicament.

VIII of Spears

Upright: VIII of Spears represents the feeling of being trapped, limited, and restricted—but the keyword here is "feeling." Though you may *feel* as though you don't have any options or ways to get out of this situation, VIII of Spears indicates that you actually do. To find them, look at things from a different perspective.

Reversed: You've found your way out of a difficult situation and are now enjoying clarity and freedom. You're moving on from this and headed in a positive direction full of new opportunities for growth and happiness.

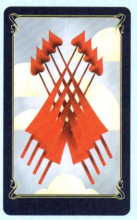

IX of Spears

Upright: IX of Spears represents worry, confusion, and anxiety. Sometimes, it can represent actual nightmares. It's time to take inspiration from Alice, who woke herself up just in the nick of time as the inhabitants of Wonderland were chasing her, and stop allowing your anxieties to get the better of you.

Reversed: Reversed, IX of Spears suggests that you're struggling with feelings of regret or remorse. You feel disappointed and sad about something that's happened in your past and are having trouble moving on from it. Don't be afraid to seek help and guidance from others if you need it.

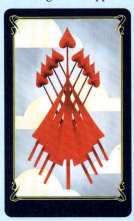

THE MINOR ARCANA

X of Spears

Upright: X of Spears represents painful endings. A friendship, relationship, goal, or project has run its course. Though you're feeling disappointed and hurt because things didn't go according to plan, know that this is a learning experience for you. Dwelling on the past will only prevent you from stepping into your future.

Reversed: Reversed, the painful ending represented by the upright X of Spears is delayed. It's time to acknowledge the truth: This isn't working out. Moving on from what's familiar can feel daunting, but trust that there's so much more out there for you. It's time to get closure and leave the past in the past.

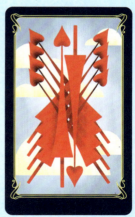

THE MINOR ARCANA

Suit of Teacups

King of Teacups

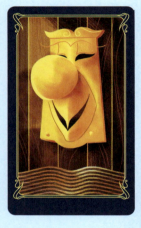

Upright: The King of Teacups represents a kind, caring paternal figure who tries his very best to help when his guidance is sought. If you're feeling overwhelmed by a challenge or conundrum, the King of Teacups suggests you seek out the wise advice of someone with experience in these matters and your best interests at heart.

Reversed: When reversed, the King of Teacups becomes vindictive and emotionally unstable. When his feelings are hurt or he feels wronged, he quickly seeks revenge. Sometimes, this tarot card can be a sign to reexamine your own reactions to emotional moments. Stay levelheaded and in control; don't allow your feelings to get the better of you.

Queen of Teacups

Upright: The Queen of Teacups represents a maternal, nurturing person much like the kind Mother Oyster. Rather than giving strict, harsh orders, she tries to guide her Curious Oysters with gentle compassion. This tarot card comes as a sign to make sure you're treating others with the empathy and understanding they deserve.

Reversed: When reversed, the Queen of Teacups indicates that it's time to turn the loving, nurturing theme of this tarot card inward. Whether you run a bubble bath, schedule a health checkup, or just make a bit of time to journal your thoughts and feelings, be sure to show yourself the same kindness you're giving to everyone else.

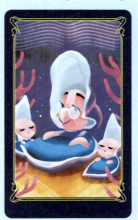

THE MINOR ARCANA

Knight of Teacups

Upright: The Knight of Teacups is a charming person with dramatic flair. Known for his chivalry, he's the first to open the door for you or shield you from the pouring rain with an umbrella. This tarot card advises you to get in touch with your emotional creativity. Pen a love letter, write a song, or redecorate in a way that inspires you.

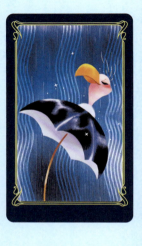

Reversed: While the Knight of Teacups can be chivalrous when upright, his reversed orientation symbolizes entitlement, jealousy, and indignation. When he doesn't get his way, he becomes moody and lashes out at others. This tarot card can be a sign to make sure you're managing feelings of disappointment or jealousy in a healthy way. Bitterness sulking won't do you any good now.

Page of Teacups

Upright: The Page of Teacups is a sensitive person whose innocence and naivety are balanced with optimism and imagination. Like sweet little Dinah, the Page of Teacups is a loyal, kind friend. This tarot card also represents new opportunities in love and friendship.

Reversed: Reversed, the childish nature of the Page of Teacups comes out. This person often handles their feelings and insecurities in unhealthy ways. This tarot card can also symbolize emotional codependency. Sometimes, you need to regain control of your autonomy and wave goodbye to someone you care about to avoid being taken along for a ride you didn't sign up for.

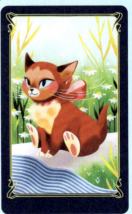

Ace of Teacups

Upright: The Ace of Teacups represents new friendships, relationships, and personal connections. Meet new people with an open mind and an open heart, because someone special is about to come into your life. Whether they're as outgoing as the Mad Hatter or as dependable as the Dodo, this person is going to end up being an important connection for you.

Reversed: Whether you're bottling up your feelings or getting carried away with them, the Ace of Teacups reversed is a sign that you're dealing with an emotional imbalance. Take a deep breath, calm yourself, and restore balance. Make sure you're neither overreacting nor ignoring your feelings.

II of Teacups

Upright: II of Teacups represents a pair as harmonious and in sync as Tweedle Dee and Tweedle Dum. This card is a clear sign of a partnership, friendship, relationship, or other personal connection that's mutually beneficial, well balanced, and happy.

Reversed: Reversed, the once-harmonious connection represented by the upright II of Teacups has hit rough waters. You may be dealing with hurt feelings and miscommunication. Choose your words carefully when handling this situation. Make sure you're being open and honest about your needs and feelings.

THE MINOR ARCANA

III of Teacups

Upright: III of Teacups suggests that it's time for a party! Even if the occasion is as simple as an unbirthday, this card indicates it's time to get together with friends and family for some fun and bonding. Let the people you care about most know just how much you appreciate having them in your life.

Reversed: Reversed, III of Teacups indicates that you're feeling at odds with a social or familial group in your life. Resist the pressure to conform to their expectations if they just don't feel right to you. You'll bloom best if you stay true to yourself, even if it means defying their demands.

IV of Teacups

Upright: You have a tough choice to make and are having trouble coming to a decision. You may be feeling overwhelmed with opportunities but unable to pursue all of them, or you may be struggling to weigh one option against the other. Use your intuition to help make this decision.

Reversed: IV of Teacups, when reversed, represents withdrawal and isolation. Introspection and self-reflection can be healthy, but be careful not to take it to the extreme. This card is a sign that it's time to come out of your teapot to reconnect with friends and family.

THE MINOR ARCANA

V of Teacups

Upright: V of Teacups represents emotional disappointment. You put your heart and hope into something, and the situation hasn't turned out as you'd hoped. Allow yourself to feel your feelings now. Disappointment hurts, but it won't last forever. Take a moment to process what's happened, then move on to better things.

Reversed: Reversed, V of Teacups indicates personal remorse. You're feeling regretful about something that happened in the past. Don't allow regret to consume you. Fix things and make amends to the best of your ability, forgive yourself, and then let go of those heavy feelings.

VI of Teacups

Upright: What makes you feel as happy as sweet little Dinah in a flower field or as cheery as the Mad Hatter hosting a merry tea party? VI of Teacups advises you to reconnect with the simple things in life that bring you joy. Go outside to enjoy the warm feeling of sunshine on your face, or call an old friend to reminisce and laugh.

Reversed: Reversed, VI of Teacups suggests you may be living in the past. Remembering bygone days can be comforting, but take care not to become so consumed with nostalgia that you neglect to enjoy all the wonders of the present moment.

THE MINOR ARCANA

VII of Teacups

Upright: VII of Teacups asks you to take inspiration from Alice and dream. Allow your imagination to wander. Daydreaming can be a powerful act of manifestation and form the framework for your future goals and actions. Tap into your intuition, and let your mind wander. Who knows what wonderful adventures your dreams will take you on?

Reversed: Reversed, VII of Teacups warns against the danger of overidealizing. Keep a level head, and don't allow yourself to get carried away with a person's or situation's potential. To avoid disappointment, make sure you're seeing things as they really are, rather than as you wish they'd be.

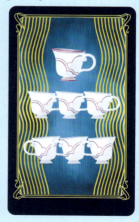

VIII of Teacups

Upright: You've recently achieved a goal you'd put a lot of energy into but aren't finding it as fulfilling as you expected it to be. It's time for introspection. If you're unsatisfied, reflect on why that may be. Self-reflection will help you discover what will make you truly happy and content.

Reversed: Reversed, VIII of Teacups represents indecision. A relationship in your life is at a tipping point, and you're not sure whether to walk away or keep trying to fix the bond. Use your intuition and instincts to decide. Even if your mind is having trouble weighing out the benefits and pitfalls of this decision, your heart knows what to do.

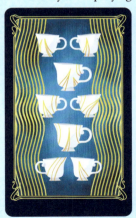

THE MINOR ARCANA

IX of Teacups

Upright: IX of Teacups is a positive sign of a successful outcome. Luck is on your side, your wish has been granted, and things are finally going your way. Stay in the present moment to fully enjoy the ease and comfort of this wonderful time.

Reversed: Reversed, IX of Teacups suggests that you're feeling dissatisfied. You're trying to get fulfillment and happiness from material things but are finding that sort of satisfaction to be fleeting. Remember that achieving deep, true satisfaction is a personal, inner journey. Focus on gratefulness and seeing things from more positive perspectives.

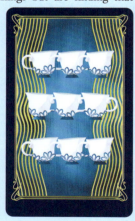

X of Teacups

Upright: *Hooray!* The X of Teacups represents stability, comfort, and happiness within your family, friendships, and other close relationships. Enjoy the company of those closest to you, because those supportive connections are the most rewarding and personally fulfilling.

Reversed: Reversed, the X of Teacups indicates that close personal connections in your life are struggling. You're no longer seeing eye to eye with family or friends, and the status of your relationships with them is up in the air. Reflect on whether or not the relationships are salvageable. Do you want to work to maintain these bonds, or have they run their course?

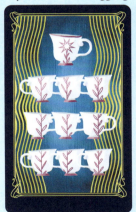

THE MINOR ARCANA

TAROT READINGS

One of the most exciting things about reading tarot—and possibly one of the reasons it's so popular and widespread—is that it can be personalized to suit your style. There are no rules! Use this deck intuitively, in whatever way feels right to you. Read tarot as often or infrequently as you like. Make it a ritualistic, sacred practice, or take out your deck casually and read the cards with friends. It's all up to you—that's the magic of it.

Caring for Your Deck

Most tarot readers agree it's important to energetically cleanse your deck regularly, especially if you read tarot for other people. Cleansing your deck leaves you with a clean slate, so your next tarot session will be fresh, clear, and unencumbered by the energy of previous readings.

There are many methods you can use to cleanse your tarot deck. Feel free to experiment with them, and choose the method that resonates with you. Smoke cleansing refers to the act of passing the tarot deck through the smoke of sacred herbs, such as sage, lavender, or palo santo. Placing your deck in moonlight overnight can cleanse and refresh your cards. Many agree the light of a full moon is the most powerful, but any moonlight will do the job. Another option is to use crystals; selenite and black tourmaline make wonderful cleansing tools. Keep those crystals on or near your deck when it's not in use to make sure its energy stays fresh, protected, and ready for the next reading.

Preparing to Read Tarot

Every good tarot reading begins with a question. You can ask the cards anything and everything: What needs to happen for this relationship to reach its full potential? Which new opportunity should I pursue? Is now a good time to chase my curiosity like Alice, or would I be better off staying dutifully focused on my work, like Bill the Lizard? Tarot reading can give you useful insight and advice about any situation, friendship, relationship, or challenge you find yourself in.

Begin tarot readings by calming and clearing your mind. Meditate, take a relaxing bath, or close your eyes for a few moments. Breathe slowly and deeply. When you feel ready, ask your question, and shuffle the tarot deck. Some people shuffle tarot cards like playing cards, while others use an overhand shuffle to avoid bending them. You can even spread them out on a large surface and riffle through them to choose cards intuitively.

When your question has been asked and your cards have been shuffled, it's time to draw cards and lay them out in a tarot spread. Tarot spreads are the specific ways cards are arranged as they're drawn. Here are a few to help you get started.

PREPARING TO READ TAROT

The Tarot Spreads

The Doorknob's Key

This tarot spread is designed to reveal the behaviors, attitudes, and circumstances that may be acting as obstacles in achieving your dreams. It will reveal what's holding you back and how to overcome those blocks so you can freely move forward.

Card 1. This card reveals the area of your life that's experiencing a block.

Card 2. This card reveals what you need to know to overcome the block symbolized by card 1.

Card 3. This card reveals what you need to shut the door on and leave in your past in order to step freely into a successful future.

Card 4. This card reveals your key to finding new inspiration.

Card 5. This card reveals the key to unlocking your true potential.

Card 6. This card reveals the key to your success.

THE TAROT SPREADS

Follow the White Rabbit

Are you ready to feel truly inspired and chase that inspiration down whatever adventurous path it may lead you with childlike excitement and wonder? This tarot spread is designed to help you reconnect with your creativity, curiosity, and imagination.

Card 1. This card reveals what's blocking your creativity.

Card 2. This card reveals where you will find inspiration in your life.

Card 3. This card reveals which part of your life needs more attention to help release the creative block represented by card 1.

Card 4. This card represents where chasing your inspiration and creativity will ultimately lead you.

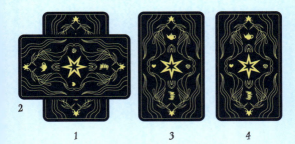

THE TAROT SPREADS

123

The Cheshire Cat's Conundrum

Have you found yourself in a curious conundrum, unsure of which way to turn? This tarot spread is designed to reveal the true nature of each choice you're presented with and offers advice on the matter so that you can be sure to make the very best decision.

Card 1. This card represents the true nature of the current situation.

Card 2. This card represents choice one.

Card 3. This card represents choice two.

Card 4. This card represents the potential benefits of choice one.

Card 5. This card represents the potential benefits of choice two.

Card 6. This card represents the potential drawbacks of choice one.

Card 7. This card represents the potential drawbacks of choice two.

Card 8. This card offers final advice on the matter.

THE TAROT SPREADS

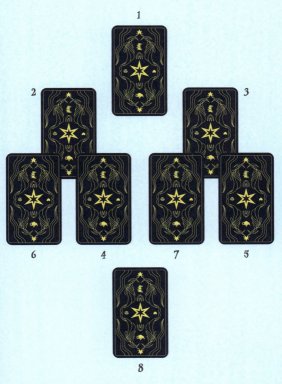

THE TAROT SPREADS

About the Author

Minerva Siegel is the author of *The Nightmare Before Christmas Tarot Deck and Guidebook*, *Supernatural Tarot Deck and Guidebook*, and *Tarot for Self-Care: How to Use Tarot to Manifest Your Best Self*. She writes about tarot, witchcraft, and living with disabilities for print magazines and online publications. When not writing, she practices divination and drinks rose lattes in the Victorian house she shares with her husband and their rescue dogs. Instagram: @SpookyFatBabe.

About the Artist

Lisa Vannini is an Italian illustrator with a degree in Japanese Studies who decided that she was probably better off as an artist after getting lost on a sacred mountain in Kyoto for six hours. She's worked as a concept artist in animation with Amazon and Jam Media, and as a freelance illustrator specializing in everything that is magical, mysterious, and out of the ordinary. In her spare time she enjoys watching Korean horror movies in her jungle-like house with her cat Moka and traveling to remote locations chasing after spooky folktales. When she's stressed she buys another plant.

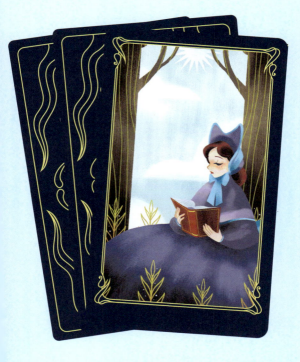

PO Box 3088
San Rafael, CA 94912
www.insighteditions.com

📘 Find us on Facebook: www.facebook.com/InsightEditions
🐦 Follow us on Twitter: @insighteditions

© 2021 Disney

All rights reserved. Published by Insight Editions, San Rafael, California, in 2021.

No part of this book may be reproduced in any form without written permission from the publisher.

Library of Congress Cataloging-in-Publication Data available.

ISBN: 978-1-64722-481-3

Insight Editions, in association with Roots of Peace, will plant two trees for each tree used in the manufacturing of this book. Roots of Peace is an internationally renowned humanitarian organization dedicated to eradicating land mines worldwide and converting war-torn lands into productive farms and wildlife habitats. Roots of Peace will plant two million fruit and nut trees in Afghanistan and provide farmers there with the skills and support necessary for sustainable land use.

Manufactured in China by Insight Editions

10 9 8 7 6 5 4 3 2 1